sisters

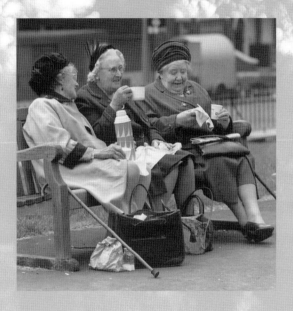

meaningful quotes on female friends

edited by tom burns

First edition for North America produced 2005
by Barron's Educational Series, Inc.

All inquiries should be addressed to:
Barron's Educational Series, Inc.
250 Wireless Boulevard
Hauppauge, New York 11788
www.barronseduc.com

Library of Congress Catalog Card No: 2004114880

International Standard Book No. 0-7641-5850-3

Conceived and created by
Axis Publishing Limited
8c Accommodation Road
London NW11 8ED
www.axispublishing.co.uk

Creative Director: Siân Keogh
Art Director: Clare Reynolds
Editorial Director: Anne Yelland
Production Controller: Jo Ryan

Picture credits: pp4/5, 106 Fox Photos/Getty Images; p18 William Vanderson/Getty Images; p27
Yale Joel/Getty Images; p67 Keystone/Getty Images; pp92/3 Bob Gomel/Getty Images; p101
Kurt Hutton/Getty Images; p117 Felix Man/Getty Images; p128 Roger Jackson/Getty Images

Printed and bound in China

9 8 7 6 5 4 3 2 1

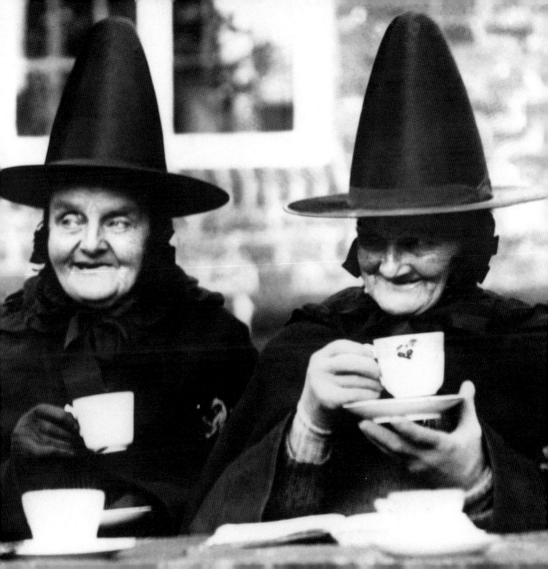

about this book

Sisters brings together an inspirational selection of powerful and life-affirming phrases about sisterhood and combines them with evocative photographs of children that bring out the full richness of our relationships with our female friends.

We all lead busy lives, and sometimes we forget to tell our sisters how much we love them and how grateful we are for their support through the good and bad times in our lives.

These inspiring examples of wit and wisdom, distilled from true-life experiences of people from many walks of life, sum up the essence of why our sisters will always have a special place in our hearts.

about the author

Tom Burns has written for a range of magazines and edited more than a hundred books on subjects as diverse as games and sports, cinema, history, and health and fitness. From the many hundreds of contributions that were sent to him by people giving their take on life, he has selected the ones that best sum up the special place in our hearts of our female friends.

Please continue to send in your views, feelings, and advice about life—you never know, you too might see your words of wisdom in print one day!

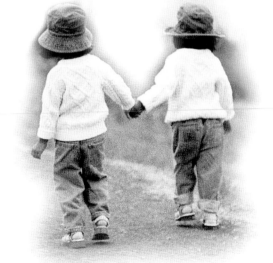

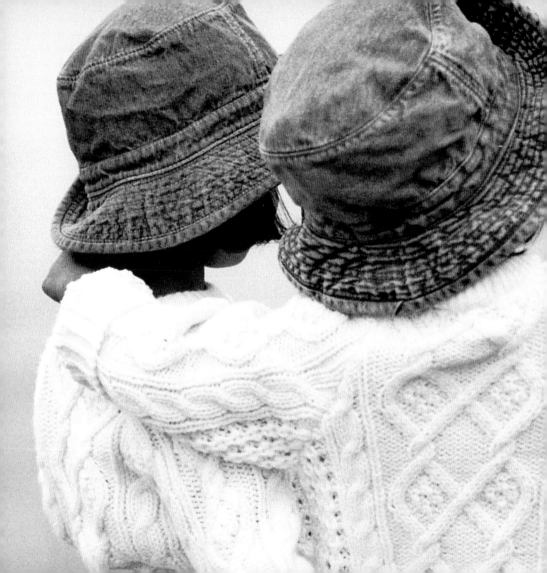

Sisterhood is a pat on the back,
a smile of encouragement.
It's someone with whom to share
and celebrate your achievements.

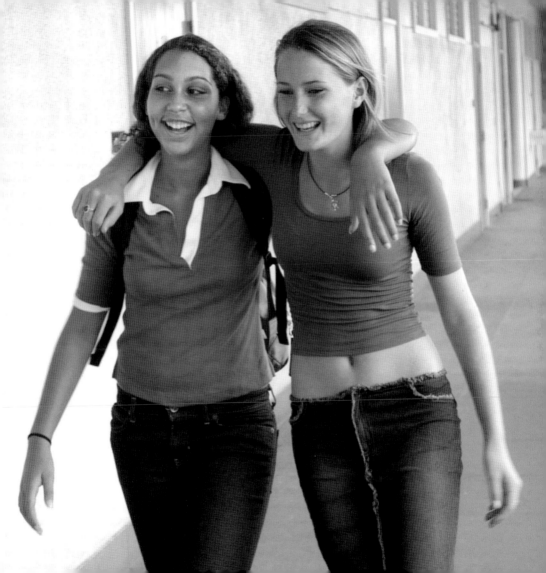

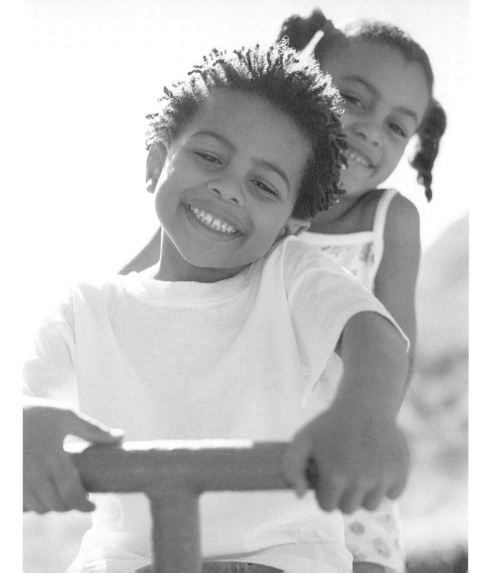

Sisterhood is not
a destination but a journey.

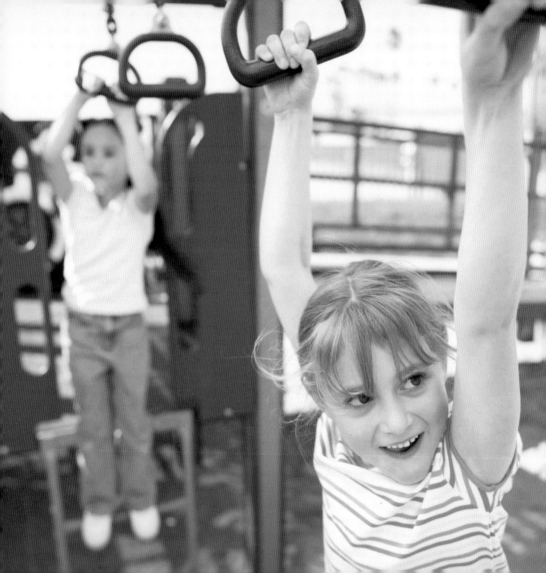

Sisterhood is having friends whom I know I can count on in tough times as well as good.

Part of the religion of
sisterhood is to help
one another.

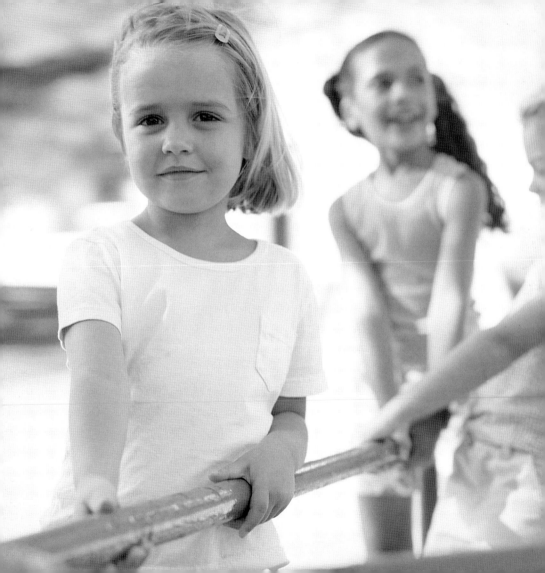

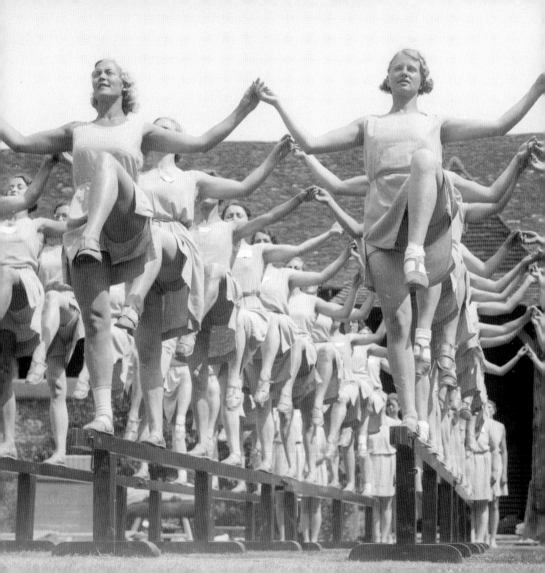

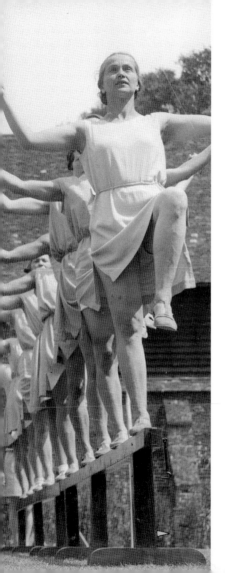

From the outside
looking in you
can never
understand it.
From the inside
looking out
you can never
explain it.

Sisterhood is powerful.

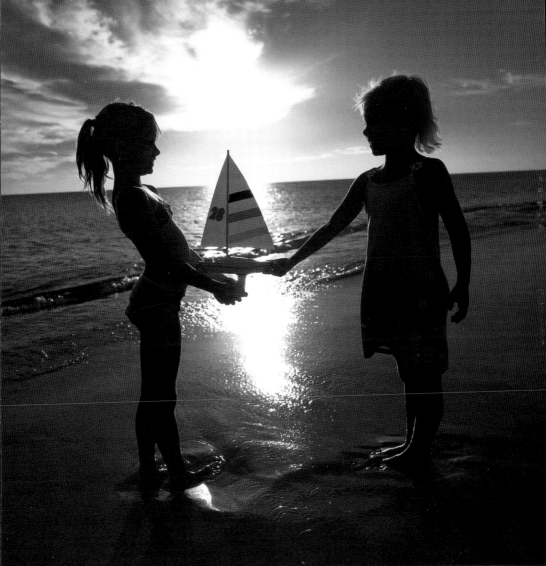

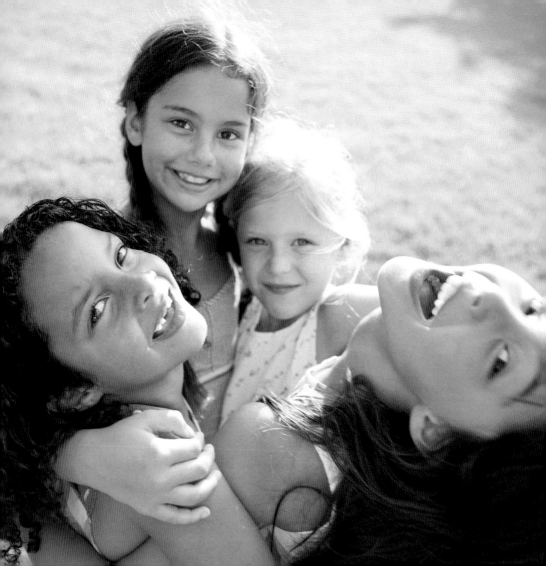

Sisterhood is a friendly face
in the crowd and a sympathetic
ear in a crisis.

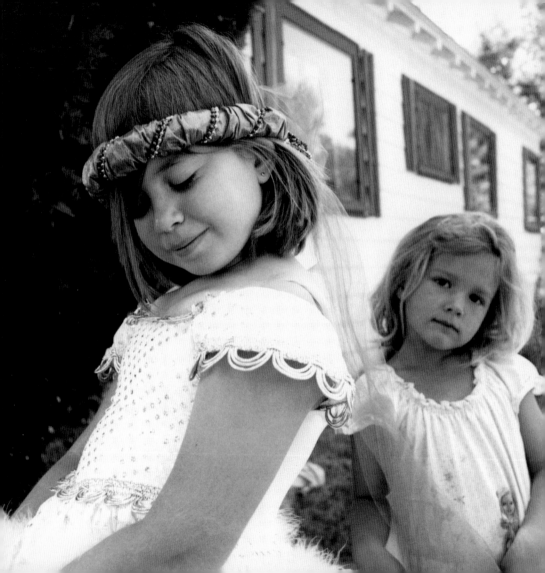

Sisterhood is not letting petty
differences get in the way
of anything. It is about being
true to yourself.

Cuts and bruises heal,
dirt can be washed off,
but sisterhood lasts a lifetime.

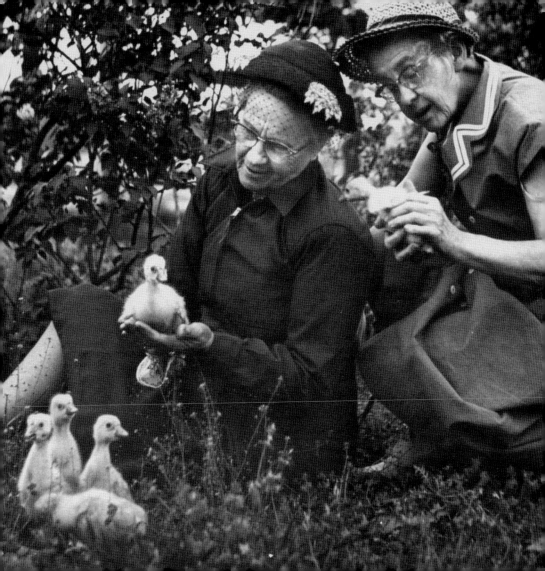

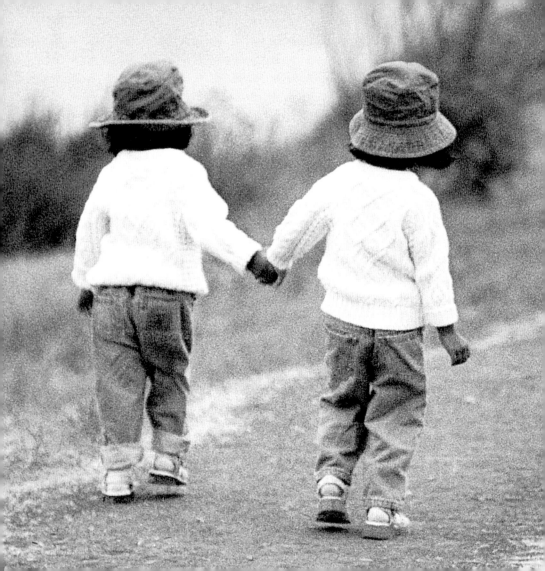

Sisters are closeness, warmth, loyalty, and trust incarnate.

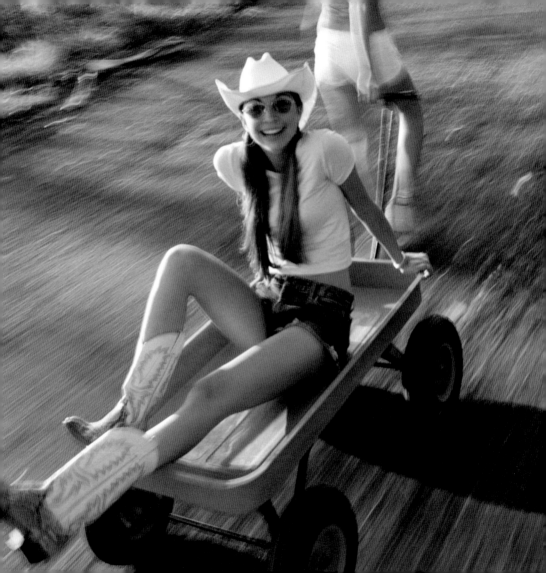

Sisters live outside the touch of time. We know each other as we always were, we share private jokes, we remember secrets, griefs, and joys.

Your sisters shine with happiness at every victory you achieve.

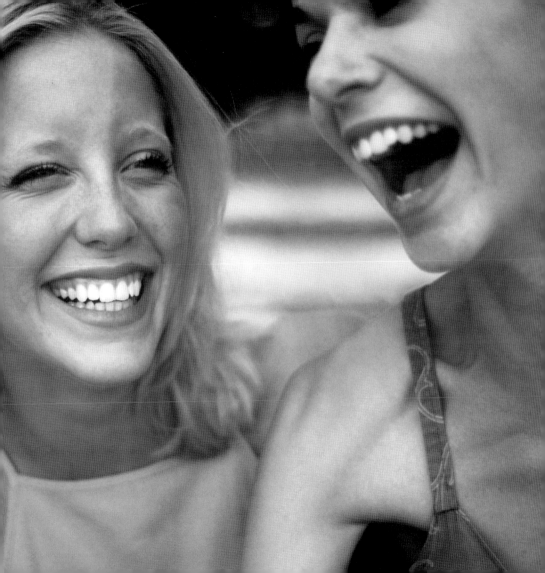

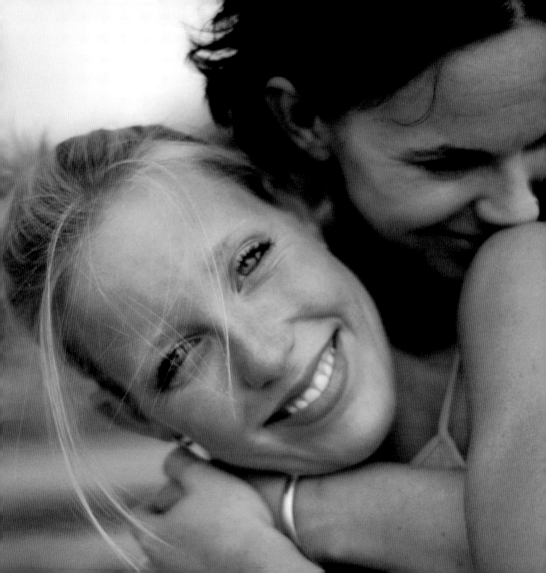

A sister is one who
reaches for your hand and
touches your heart.

Sisters are there
in times of catastrophe,
defending you against
all comers.

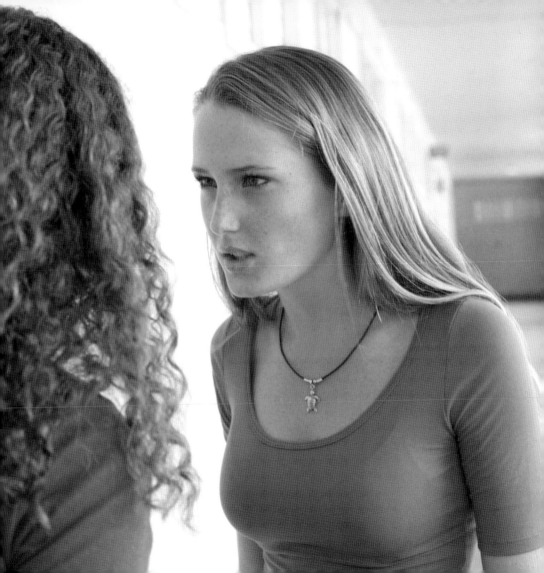

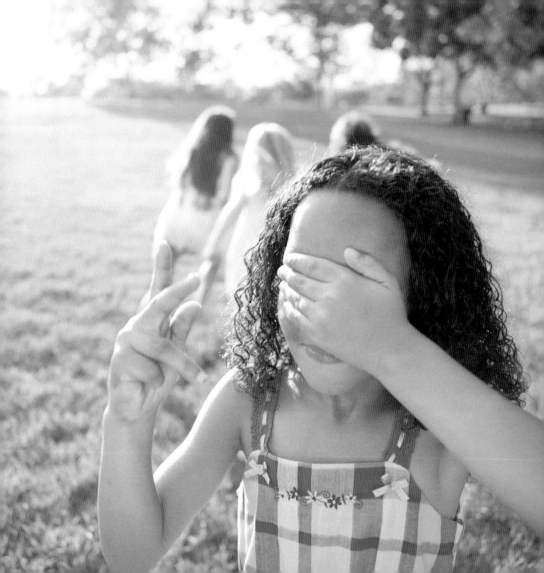

Sisters are hard to find, harder to keep, and impossible to leave.

No matter where I go or what I do, where I have been or where I will go, what I have done or what I will do, I know my sisters are there for me.

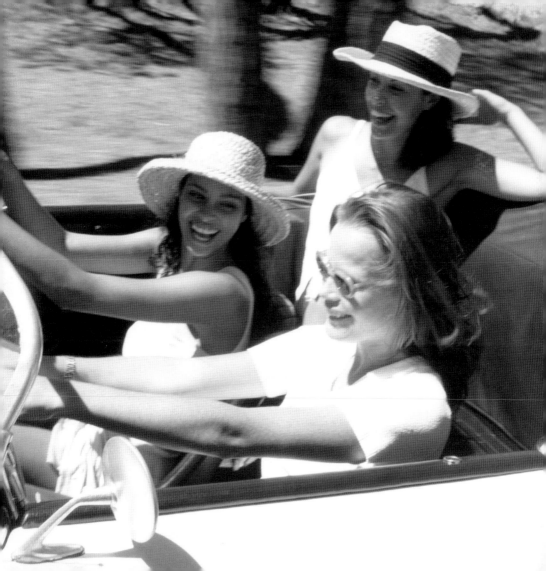

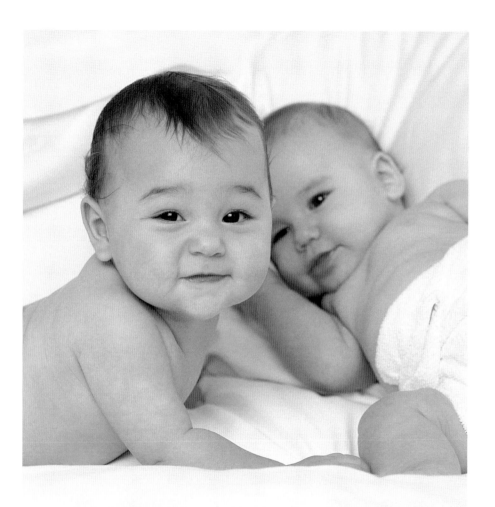

A sister is one who will pick you up when you are down. If she cannot pick you up, she will lie down beside you and listen.

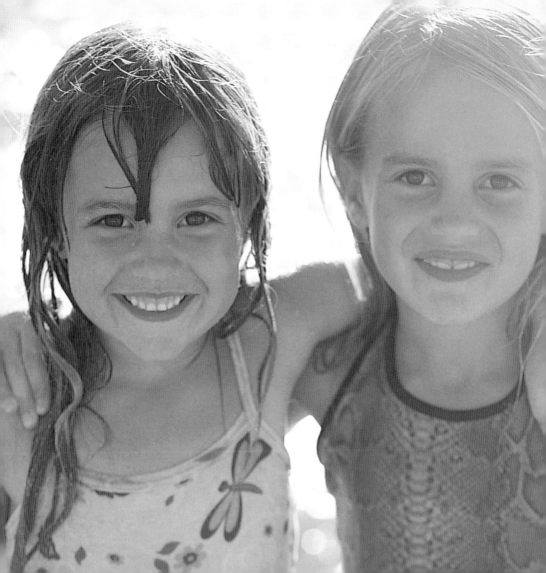

Our sisters interpret
the world and ourselves
to us, if we take them
tenderly and truly.

Sisters are there for
each other, a safety
net in the chaos of
the world.

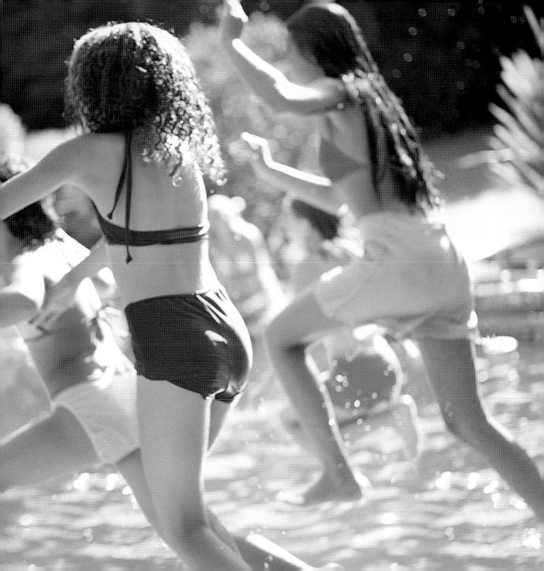

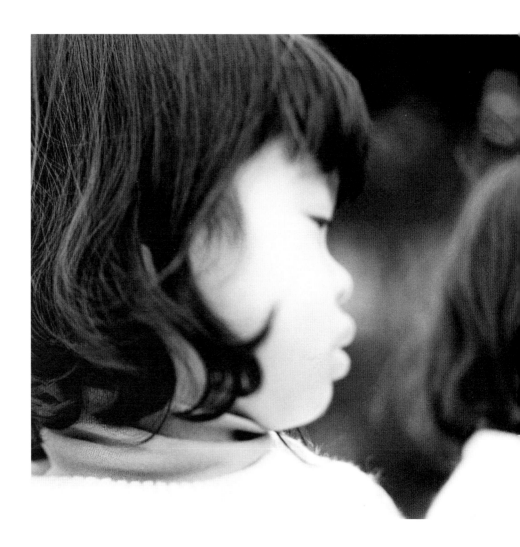

A sister is a special
kind of double.

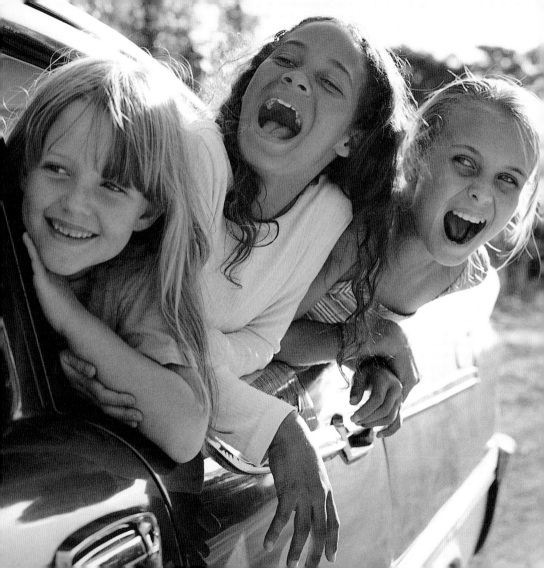

Sisters are for sharing
laughter and wiping tears.

We're not sisters by birth
But we knew from the start,
God put us together
To be sisters by heart.

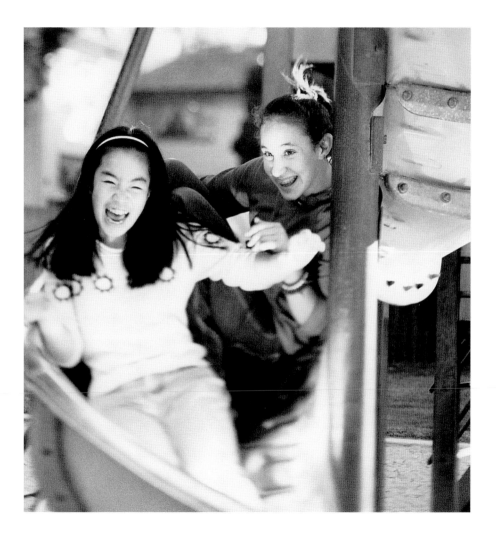

Sisters may rise and fall, but in the end we'll meet our fate together.

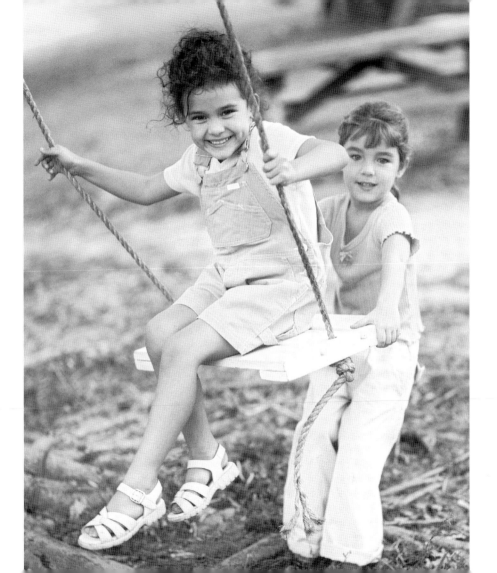

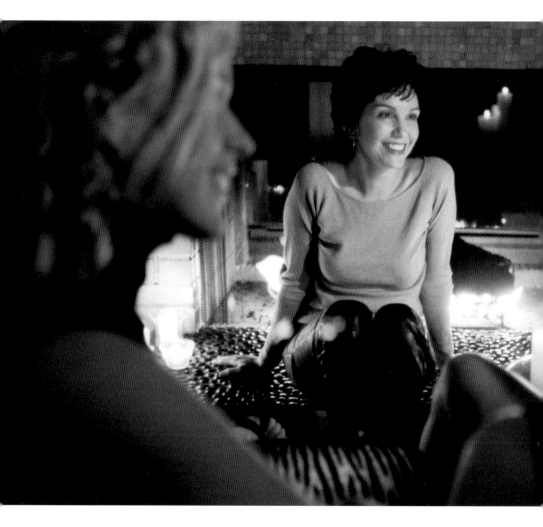

My sisters are
the only people
with whom I am
truly me.

A sister is a friend and defender, a listener, conspirator, counselor, and sharer of delights.

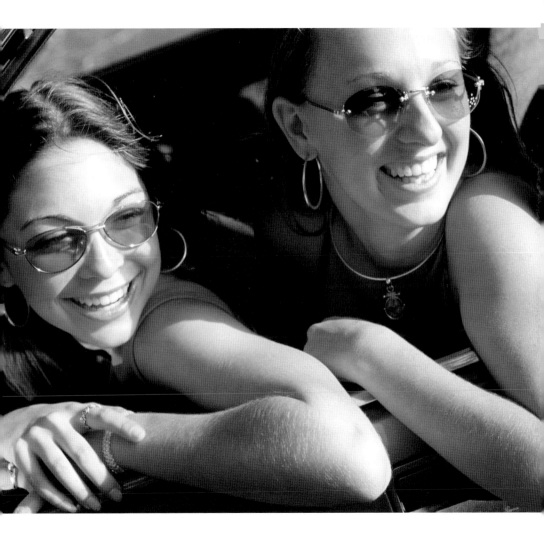

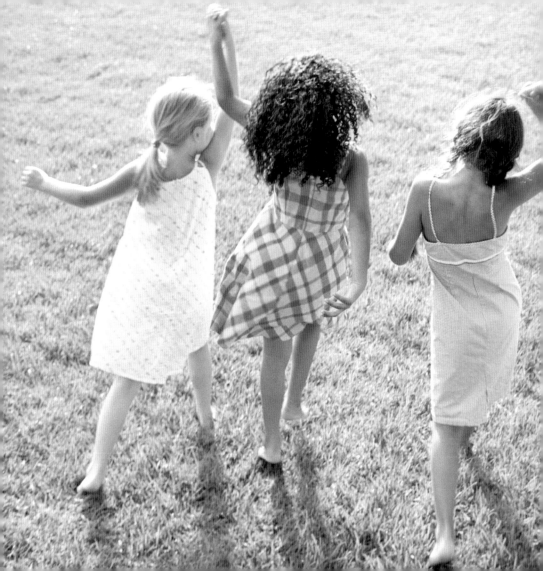

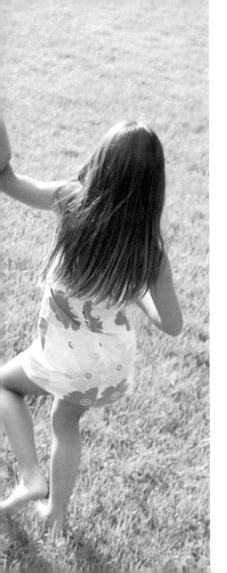

Wherever you go,
no matter how
long we are silent,
we will always be
bound together.

A true sister has all
the best qualities of both
a sibling and a friend.

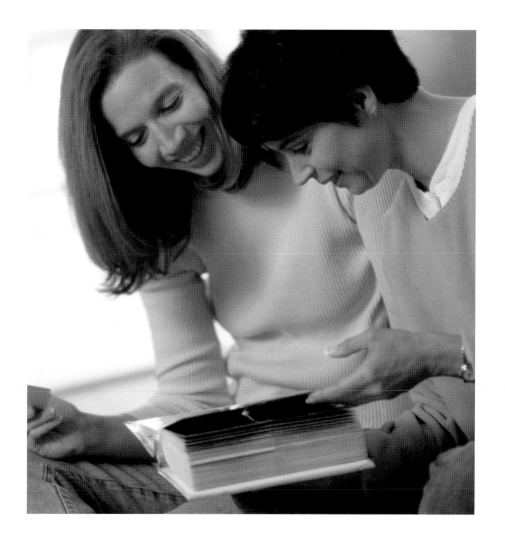

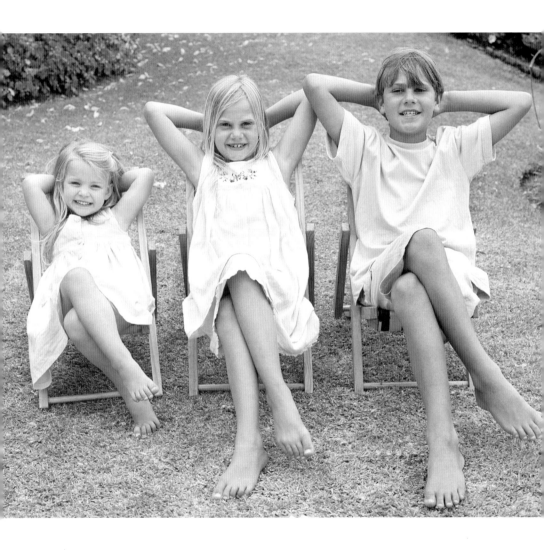

My sisters are like me,
but very much not like me.

A sister smiles when you tell your story, since she knows where it has been embroidered.

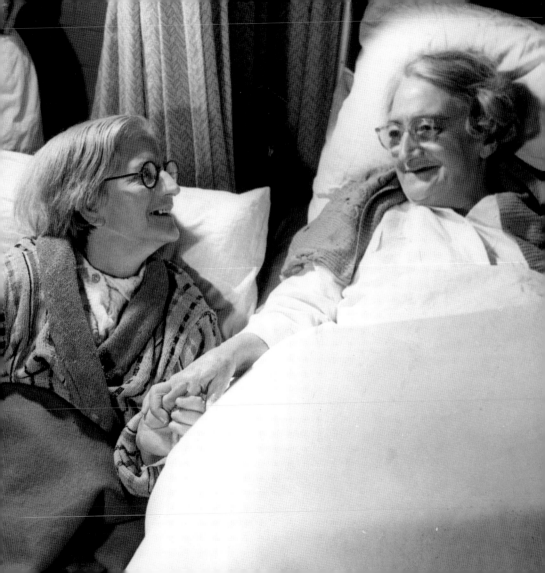

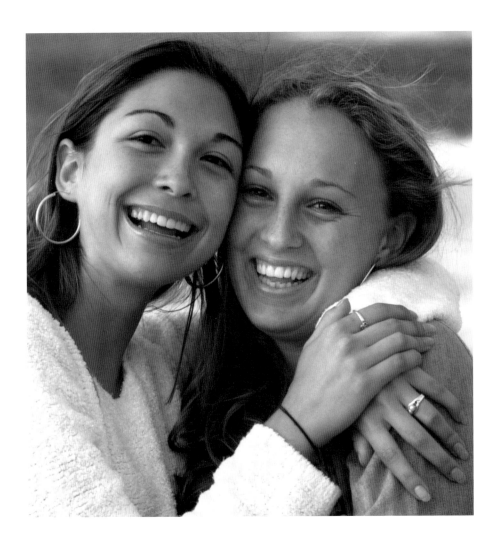

A sister is a forever friend.

A real sister is one who walks in when the rest of the world walks out.

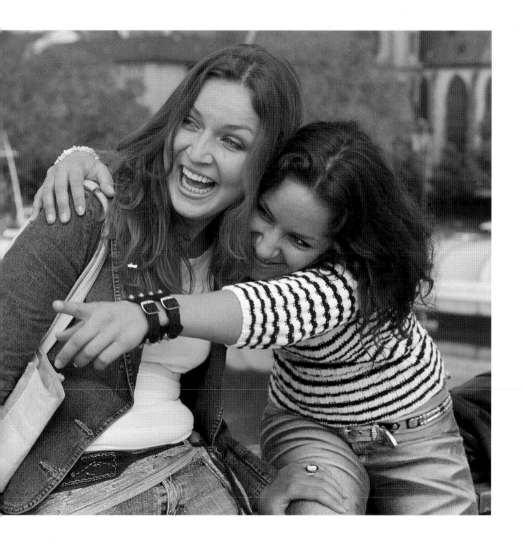

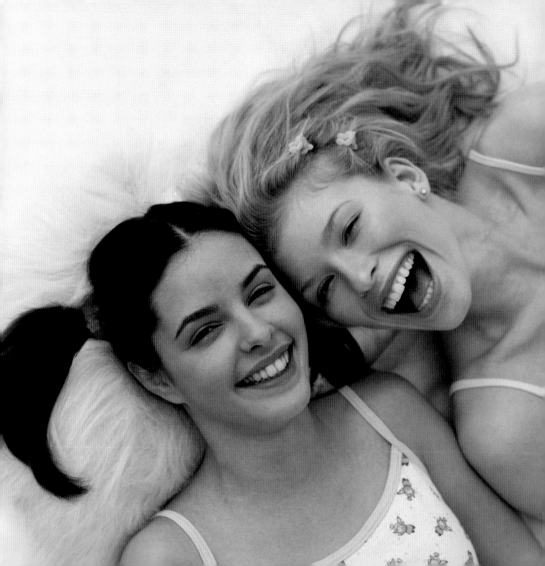

Sisters make your
heart smile.

Sisters share rainy days
as well as sunny days,
and treat them both the same.

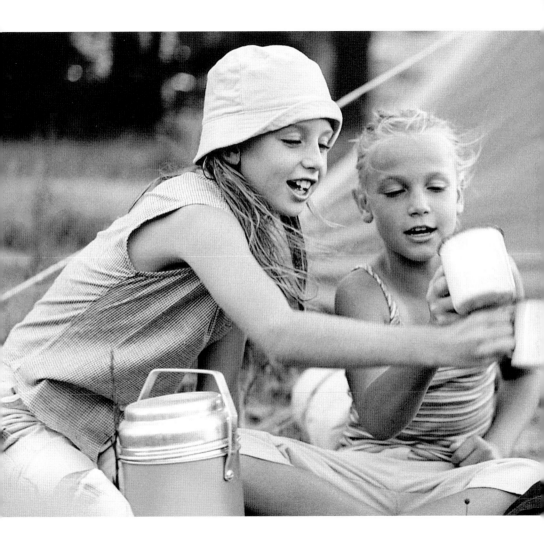

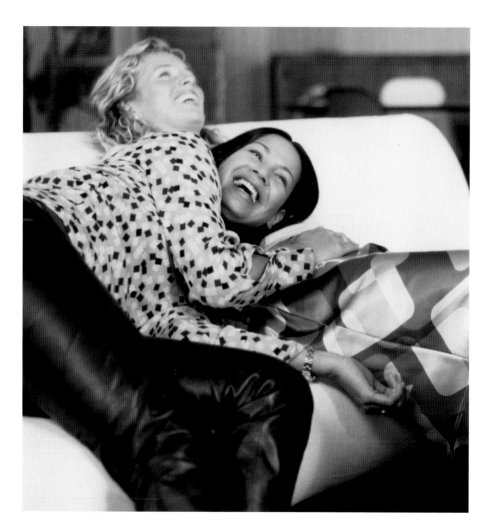

A sister is a friend to the spirit and a gift to the heart.

A sister is a gift from God,
sent from above to make life
worthwhile here below.

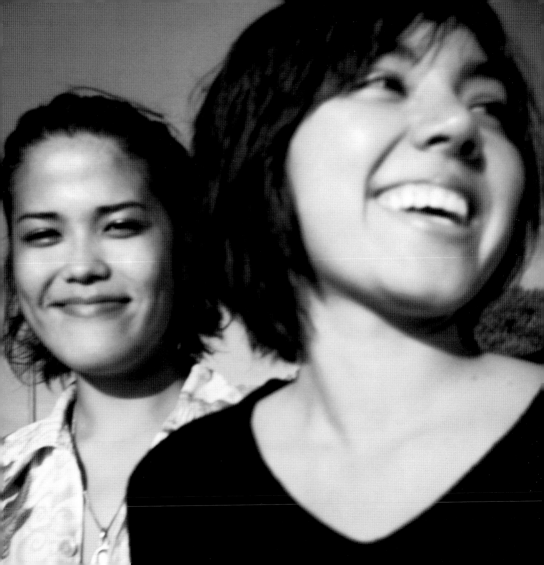

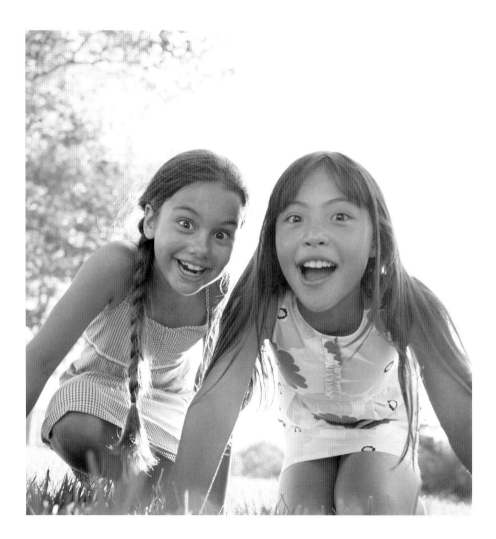

Sisters know when we are lonely, and appear without being called.

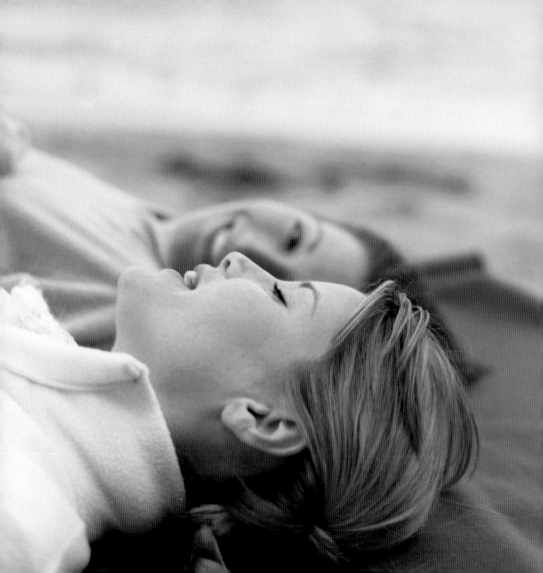

A sister is an oasis of calm in a world that has gone mad.

Sisters never judge, they only love without reservation and support without fail.

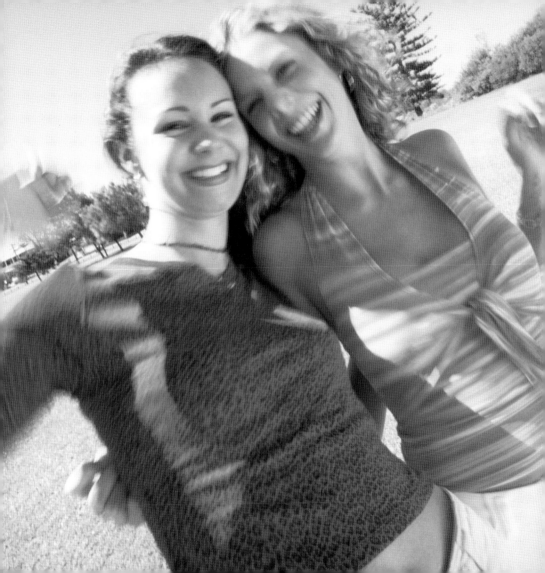

Love your sisters and your college days—for they will be sheltered in your heart forever.

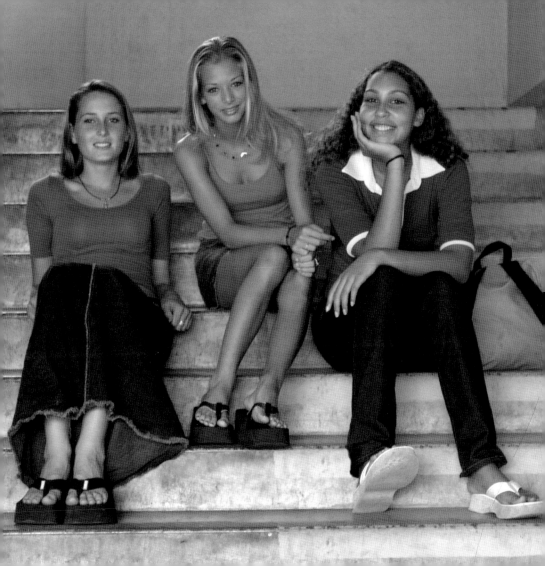

How do people make it through life without their sisters?

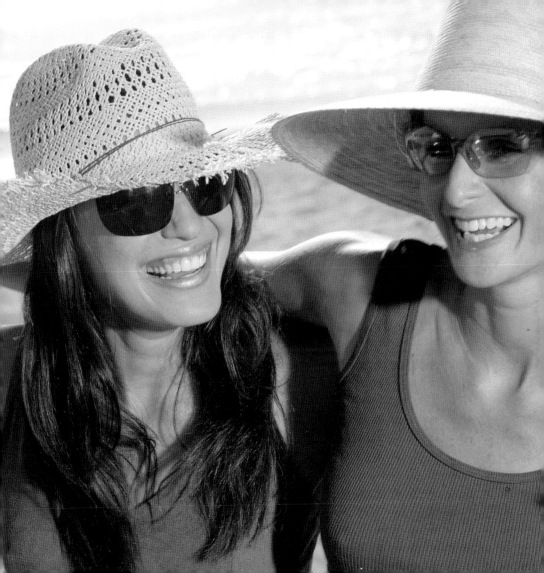

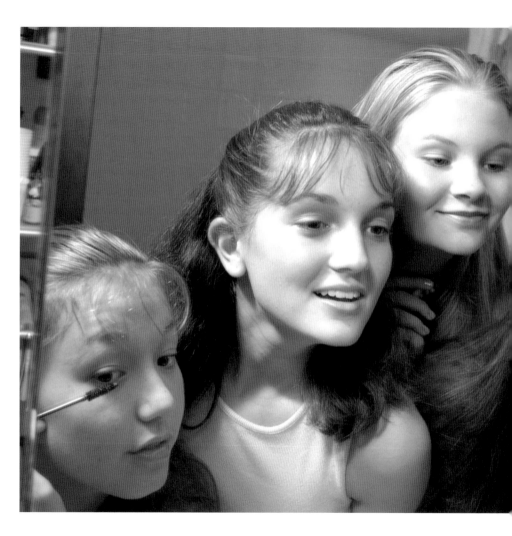

When sisters stand shoulder to shoulder, no one stands a chance against us.

Solace is most comforting in the arms of a sister.

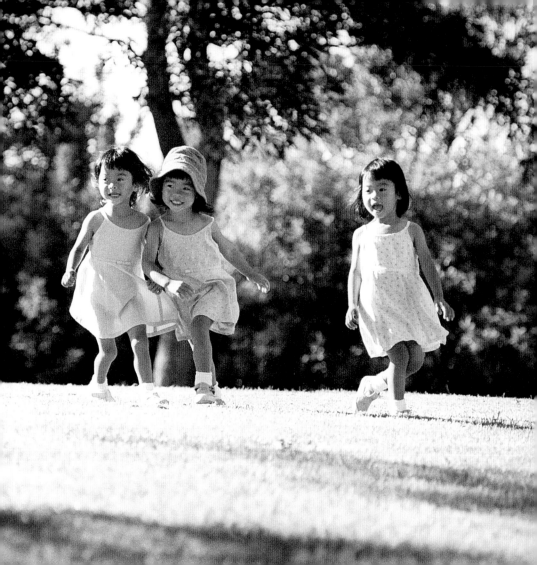

There is destiny which makes us sisters… no one goes her way alone.

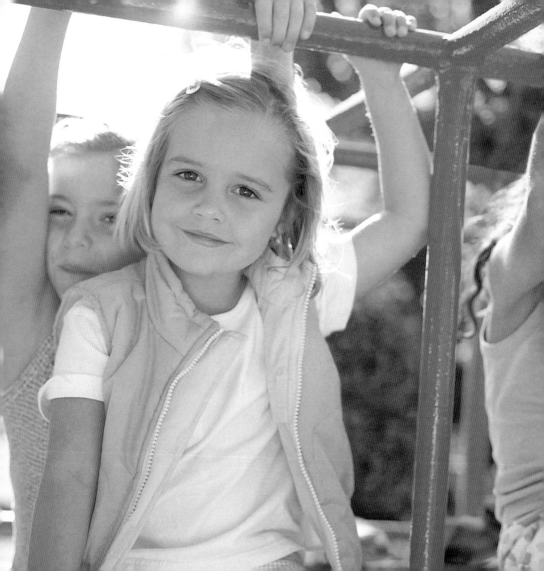

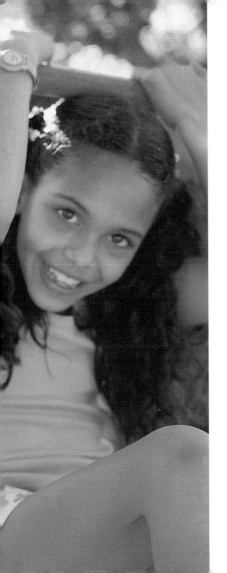

The more sisters
you have, the
easier it is when
one moves away or
otherwise becomes
unavailable—
I wish I had more.

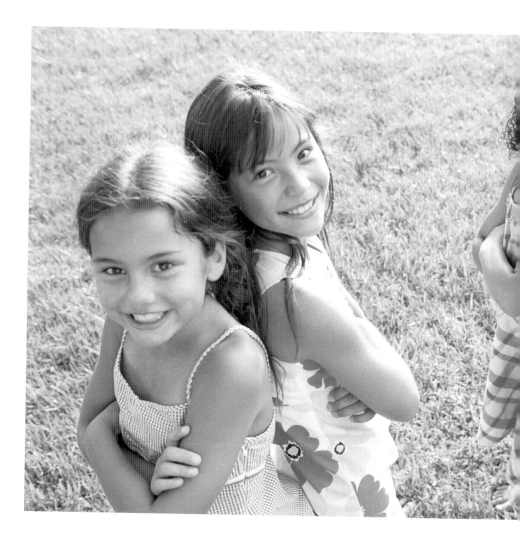

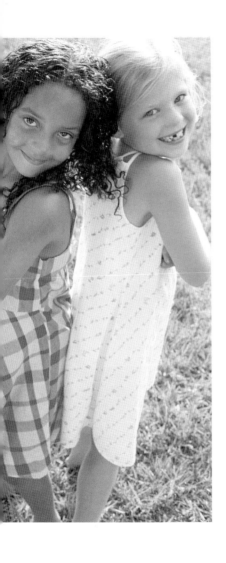

With my sisters
beside me, I can
take on the world.

The voice of a sister is sweetest
in times of sorrow.

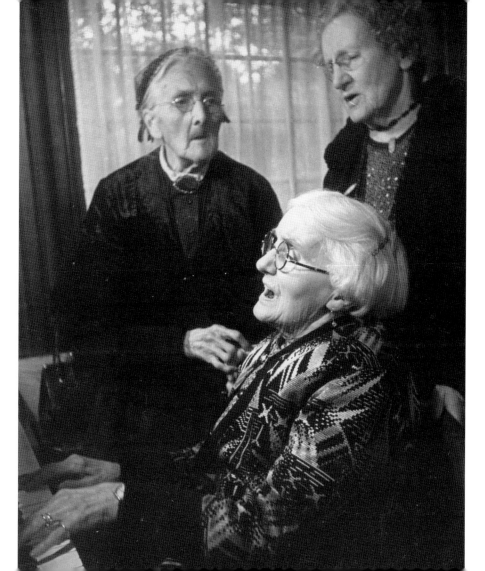

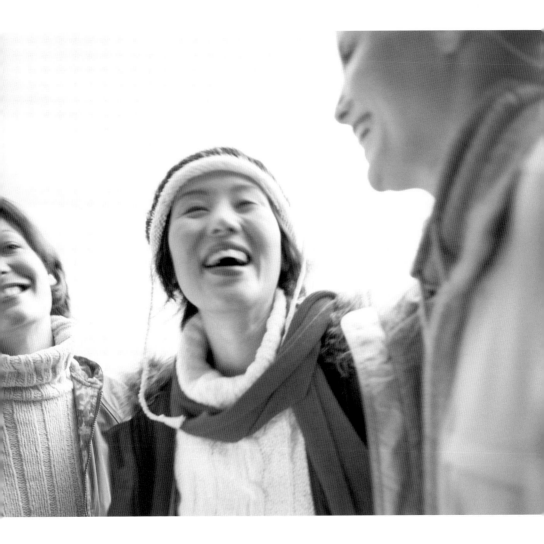

The conversation of my sisters
is a constant comfort to me.

Good news is worthless without
a sister to share it with.

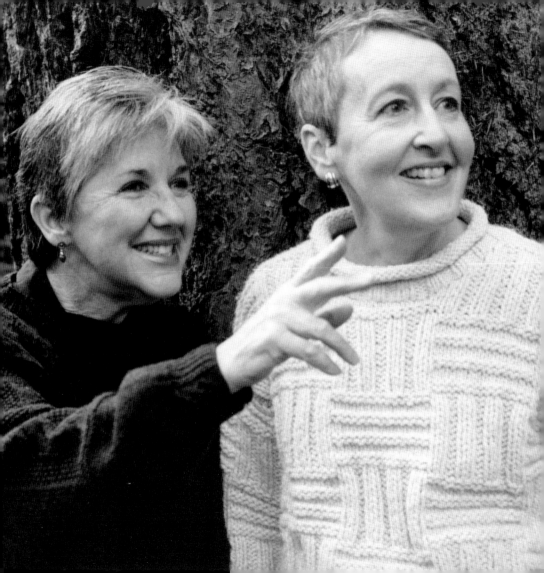

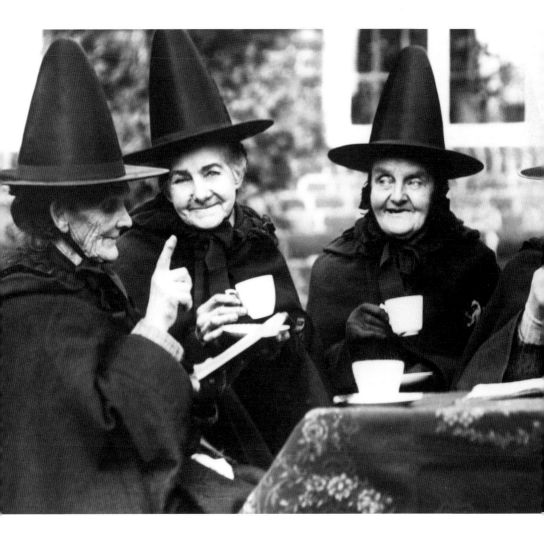

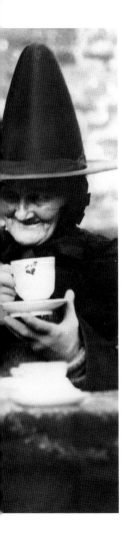

You can kid the world, but you can't kid your sisters.

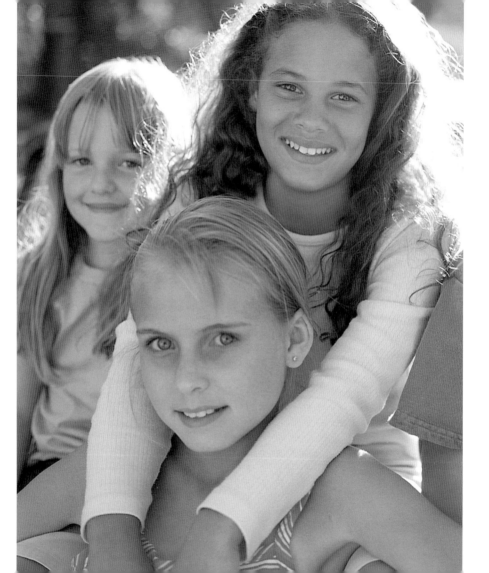

It is easiest to see the world when you're standing on your sister's shoulder.

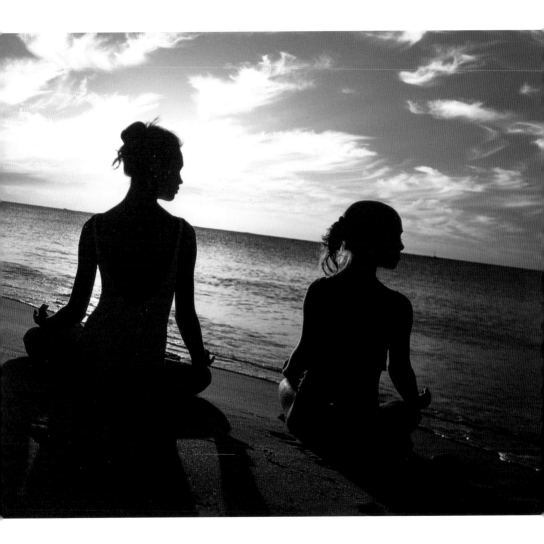

Last night I looked up at the
stars and matched each one with
a reason why I love my sisters,
and I was doing great until
I ran out of stars.

There's a special kind of freedom sisters enjoy. Freedom to share innermost thoughts, to ask a favor, to show their true feelings. The freedom to simply be themselves.

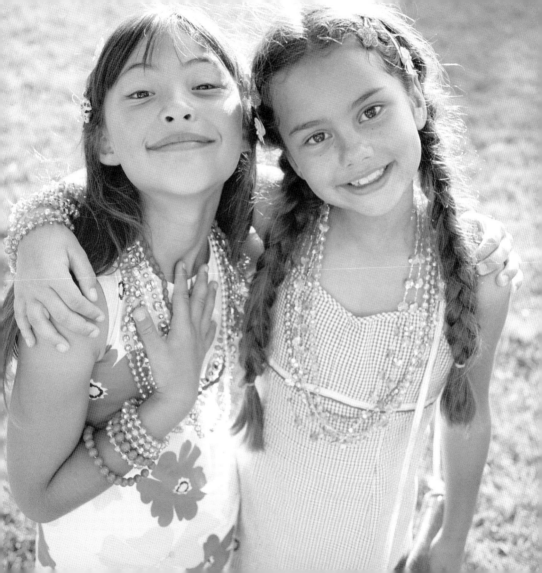

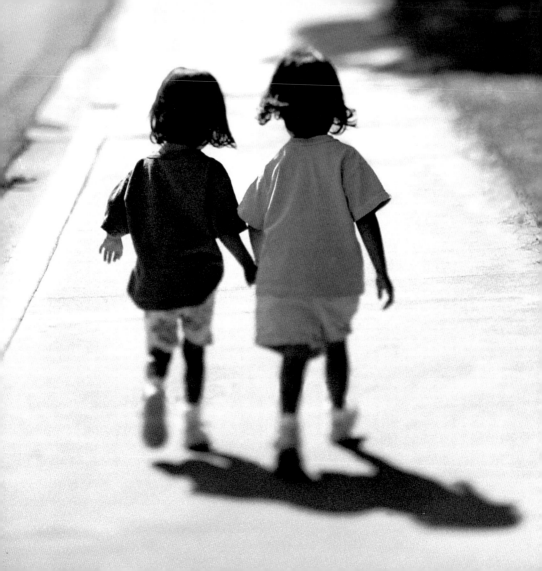

I have a hand
And you have another
Put them together
And we have each other.

The ties that bind me
to my sisters are not wrapped
around my wrists, but rather
are fastened to my heart.

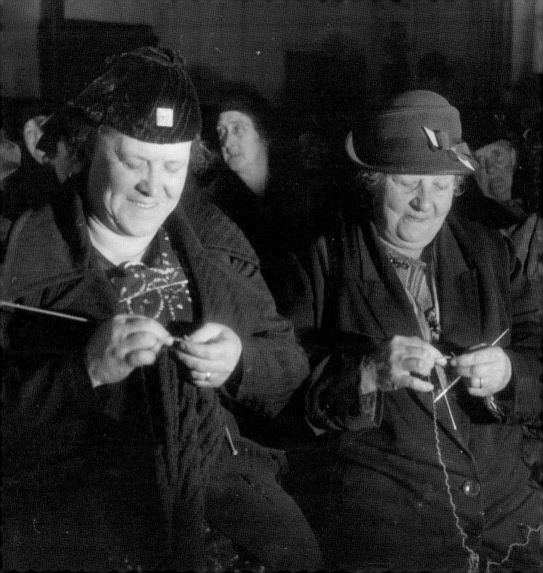

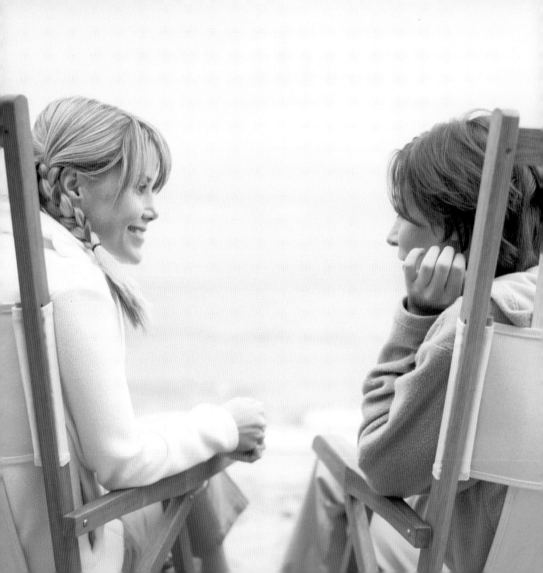

When you're not there, sister,

the color goes out of my life.

The whisper of
a sister drowns
out the shouting
of a stranger.

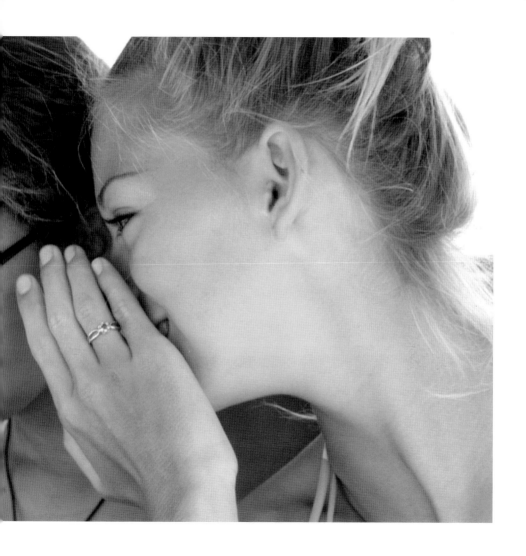

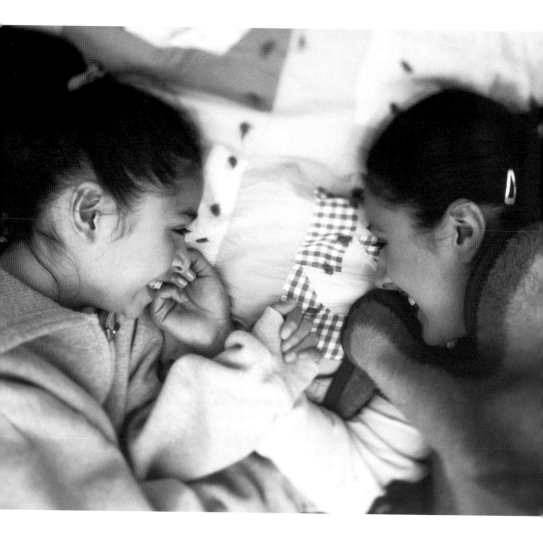

My sisters are tucked so
close to my heart there
is no chance of escape.

When men fail,
sisters prevail!

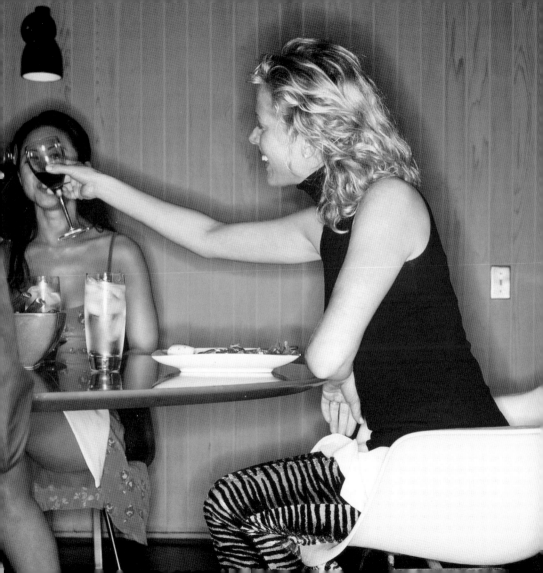

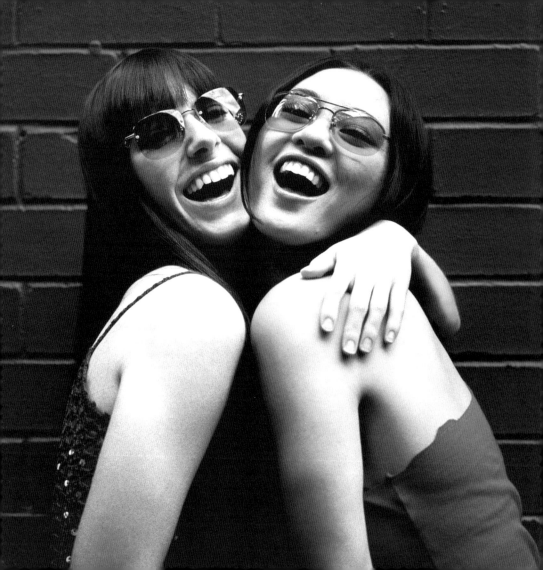